759
12075F

# THE LIFE AND WORKS OF
# ANDY WARHOL

Trewin Copplestone

SIENA

**The Life and Works of Andy Warhol**

Parragon Book Service Ltd would like to thank the Andy Warhol Foundation for their co-operation in the creation of this monograph.

All works © The Andy Warhol Foundation for the Visual Arts, Inc., New York, 1994

This edition first published in Great Britain in 1995 by
Parragon Book Service Limited
Units 13-17 Avonbridge Industrial Estate
Atlantic Road
Avonmouth
Bristol BS11 9QD

© 1995 Parragon Book Service Limited

ISBN 0-7525-1180-7

Printed in Italy

*Editors:*　　　　　Barbara Horn, Alexa Stace, Alison Stace, Tucker Slingsby Ltd
　　　　　　　　　and Jennifer Warner

*Designers:*　　　　Robert Mathias • Pedro Prá-Lopez, Kingfisher Design Services

*Typesetting/DTP:* Frances Prá-Lopez, Kingfisher Design Services

*Picture Research:* Kathy Lockley

# ANDY WARHOL   1928-1987

It is difficult to write about artists of the recent past without recognising a subjective involvement. They may be too close to our own experiences and our personal interpretation of them for a balanced, objective assessment of their work. We tend to feel that artists of our time either have a personal significance for us or we have little interest in them. Unlike historical figures, they do not have that helpful sense of distance which enables us to assess their qualities objectively and dispassionately, even when the intellectual or emotional content is considerable.

Andy Warhol is an interesting case in point. He is usually described as a Pop artist, which, in some ways he was; but in some more important ways, disguised by the label, he was not.

Andrew Warhola, born in 1928 in Pittsburgh midway between the two World Wars, was the son of immigrant parents from Slovakia who had first arrived in the US in 1907, although it was not until 1921 that his mother was able to settle in America. Andrew was born at the time of the Wall Street Crash (1929) and the Great Depression. Like millions of others, Warhol's father was thrown out of work and Andrew's early childhood was deprived and difficult. After some years the fortunes of the family improved and following his early education he attended a commercial design course at Pittsburgh's Carnegie Institute of Technology. He was at this time a shy, insecure youth with a strong fear of failure, despite a successful period at the Institute during which, through the writings of Joseph Albers and Maholy Nagy, he became familiar with the design work of the Bauhaus in Germany, the

most important school of modern design of this century.

In 1949 Andrew Warhola moved to New York. One of his first commissions was for a series of shoe illustrations and when they appeared, the final 'a' of his name was omitted from the credit line and thereafter he was Andy Warhol (a first name that seems to carry a suggestion of youth). He quickly became a successful and highly paid commercial artist in the 1950s, but longed for wider recognition and fame as an artist. He had a number of exhibitions in New York, but sold little. Deeply depressed at his lack of success as an artist, despite – or perhaps because of – his continuing success as a commercial artist (for which he won a number of important awards), by the end of 1961 he had reached the conclusion that the 'fine art' world had rejected his art as old-fashioned and irrelevant.

He needed a new stimulus and new ideas and in a somewhat strange way he got them. He asked a gallery owner he knew, Muriel Latow, for some suggestions on the direction he should take. She is reported to have said 'Yes, but it will cost you money' 'How much?' 'Fifty dollars'. He paid, and got the advice to paint what he loved most – money, or, alternatively, to paint what everybody would recognise, like soup cans. From this meeting came his paintings of the early 1960s and the beginnings of a career of almost unparalleled financial success and international fame. The progress of his imagery from soup cans is illustrated in the pictures that follow.

Warhol, as has been noted, is identified with Pop art, sometimes being credited with its 'invention'. This is a misunderstanding of his full artistic career. There were, indeed, three different forms of Pop in Britain between 1955 and 1963 which preceded Pop in New York; and this itself was anticipated by others before Warhol, notably in the work of Jasper Johns and Robert Rauschenberg, neither of whom were, however, Pop artists themselves. Pop is a much more intellectually complicated

statement than is often supposed. Its ability to create memorable totemistic images and an awareness of generative forces in society give it the importance that it holds in the development of modern art. It is not simply that it portrayed popular icons, such as Warhol's Marilyn Monroe, or popular ephemera, such as Lichtenstein's enlarged strip cartoon images, but that these images were so easily acceptable as appropriate to the way we live now that they refocused society back on its own values to a degree that no traditional forms of painting could have done. There is in consequence a serious sub-message in the work of Pop artists which is not apparent at first sight. The pop artists were aware of this and exploited it. In Warhol's later disaster paintings, for instance, he portrays the 'illth' in society, as John Ruskin described it in the 19th century, that is the downside of modern civilisation that has to be set against the 'wealth' – the benefits it brings: for example death and injury that the car brings against its obvious advantages. It is this factor of focus, and not the common artefacts used, that gives Pop, and particularly the work of Warhol, its significance.

During his working career, Warhol used a considerable number of different methods and media and, in addition, created the same subject in different media and by different methods. It is not possible in all instances to be certain how his results were achieved. In general, however, before 1962 he used paint – acrylic or oil – and stencil for his subjects, including the repeated series of images, e.g. the *Campbell Soup* cans. After 1962 he used variations of a photomechanical silk-screen process. Where a different method has been used this is indicated, for example, the *Roll of Bills*.

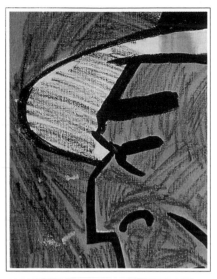

*Detail*

▷ **Dick Tracy** 1960
Casein with crayon on canvas

BY THE MID 1950S WARHOL was
highly successful as a professional
designer/illustrator, but began to
aspire to wider fame as an artist.
Much influenced by Jasper Johns
and Robert Rauschenberg, he
turned to the depiction of popular
objects such as Coca Cola bottles
and subjects taken from strip
cartoons, as did his contemporary
Roy Lichtenstein. The difference
between them lay, significantly, in
the choice of subjects; Lichtenstein
painted anonymous popular types,
while Warhol depicted hero
figures such as Dick Tracy. The
treatment is bold but casual,
coarse drawing showing that the
strip image may become
transmuted into art by the artist;
however mundane, inane, or
commonplace the source, the
artist may metamorphose it
into art.

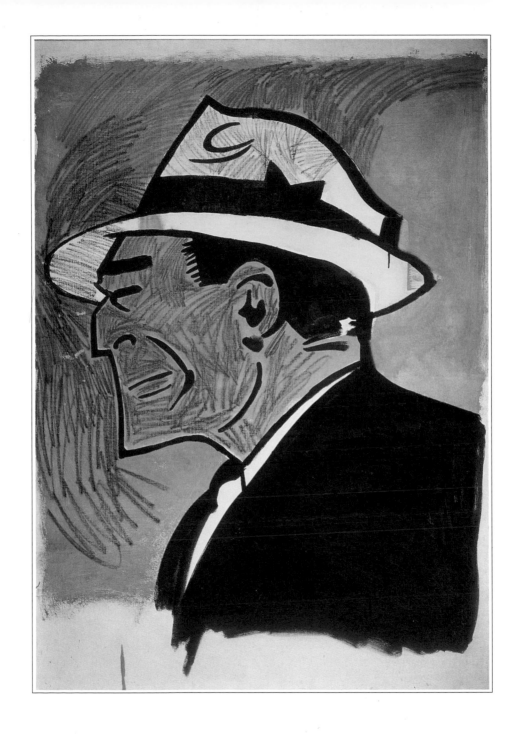

*Detail*

▷ **Dance Diagram (Tango)** 1962
Synthetic polymer paint on canvas

THIS PURSUES HIS INTEREST in the images of popular culture, through which he not only hoped to create his reputation, but also to concentrate the minds of his public on the essential importance of transient things. In this way he stimulates, much as the Surrealists did in the 1930s, a conscious awareness in the observer of a physical relationship with the whole natural world. This *Dance Diagram* is one of a number of dance diagrams that Warhol produced and which were exhibited horizontally, but stretched and raised off the ground. It was therefore also intended to raise questions about how important dance ritual might be.

**START**

## ▷ **Coca Cola** 1962

AMONG THE MANY OBJECTS that
Warhol used to identify the nature
of the great American society,
anonymous and consumerist,
devoted to conformism and with a
pride in unanimity, was the
ubiquitous Coca Cola bottle –
easily identified in shape, and
clearly full (rich brown) or empty
(pale green) (see opposite). Always
providing a before and after
comparison it stands full for an
unsatisfied thirst, unfulfilled
longing, and empty as a
recollected universal symbol of
Americanism. As Warhol himself
observed, there is only one coke
and everybody from presidents
and film stars to the poorest in
society all drink exactly the same.

Two examples are shown here.
The first is of a single bottle
composed within the picture area
like a still life in which the words
and bottle make a formal
composition, with the incomplete
legend indicating that it is a
picture not a poster.

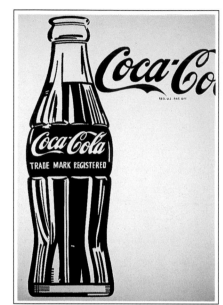

*Detail*

## ▷ **Coca Cola Bottles (210)** 1962

IN THIS PAINTING 210 COCA COLA
bottles are arranged as if they are
shelved in a supermarket. But
since some are empty and some
only partly filled, Warhol is again
showing the artistic effort rather
than the uniformity of normal
display. The essential element of
artistic involvement is explained,
when it is realised that the
background is painted (brown/
green), but the black 'line-drawing'
of each bottle is silkscreened. It is
also important to realise that this is
a modern equivalent of the
traditional still life. There is
nothing intrinsically important in
a bottle or an apple that makes a
still life significant – it is the
quality of the painter, a Chardin
or a Cezanne, that gives the value.
An old wine bottle or a coke bottle
are the same – except that the
coke bottle, particularly as treated
by Warhol in multiple images, is
more to do with contemporary
society than is an old wine jar.
For the sensitive observer it could
indeed be that the complexities
of inspiration and imagination
Warhol's painting evokes are
more powerful than any by
Chardin or Cezanne.

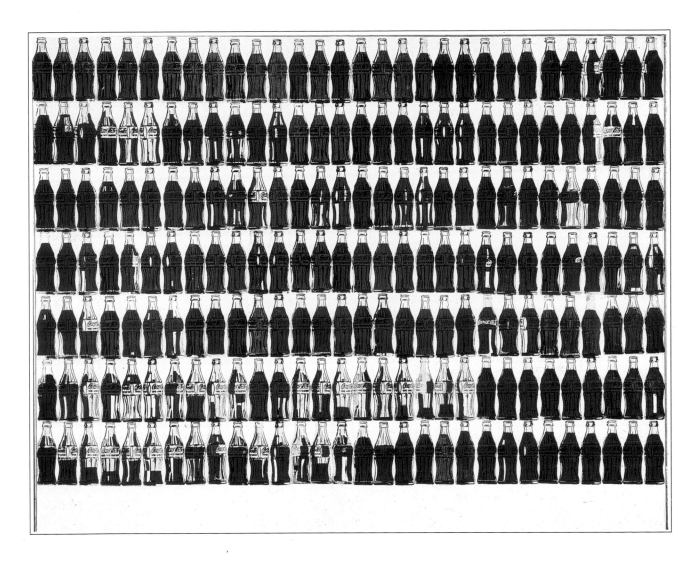

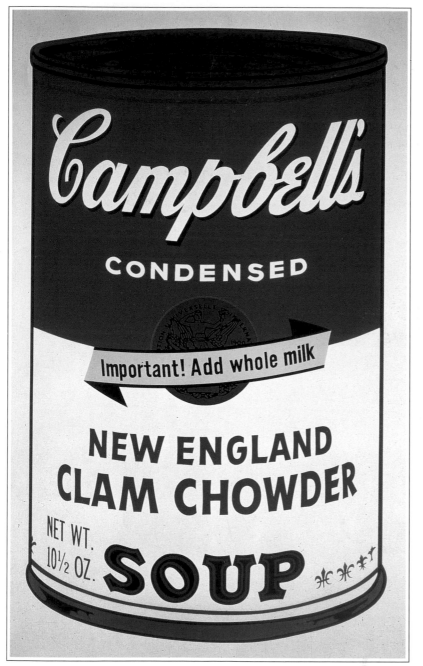

◁ ▷ **Campbell's Soup Can (Tomato, New England Clam Chowder)** 1969
Print

WHEN MURIEL LATOW SOLD WARHOL her ideas – as recounted in the introduction – she specifically suggested Campbell's soup as a recognisable-by-all common object and Warhol thought it a 'fabulous' suggestion – to the extent that on his next visit to the supermarket he bought the whole range of different soups and made thirty-two individual paintings of them. These became the content of his first one-man exhibition and were displayed in a single line around the gallery, every one the same, but different. His exploration of the subject matter, reflecting perhaps his commercial art experience, included inventing new colourways for each and turning them into damaged items. Could it be analogous to the human race – or to experience? Could the repetitive images move the world – what next? When variety is thus removed a new dimension of intensity is created which does concentrate the mind wonderfully on the limits of identity.

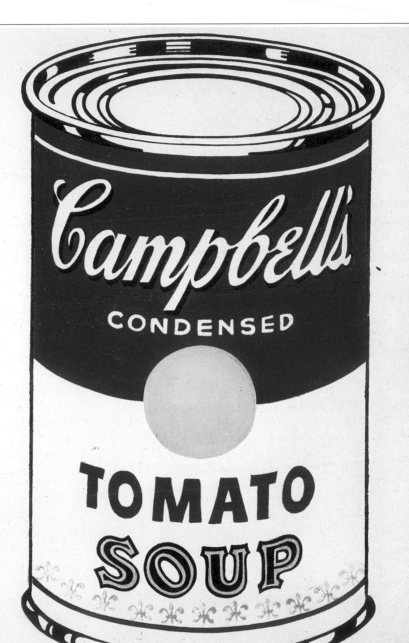

*Detail*

## ▷ **Big Torn Campbell's Soup Can (Vegetable Beef)** 1962

IN THIS EXAMPLE OF THE *Campbell's Soup* can series Warhol has made a very different statement in very different terms from the previous pictures (see pages 14 and 15). This is a painting of an actual can with its specific defects – departure from the norm – and with a graphic commercial art treatment. This is a 'traditional' picture of a damaged soup can – a single image still life. There is a clear unequivocal message here. The perfect object can suffer deterioration or damage. But there is of course more to it. Only the outer cover, the skin, is damaged – the tin and, presumably, the contents, are still perfect (and uniform) except that without the skin the perfect soup could be bean, onion, chicory etc. To anthropomorphize, 'everyone is different but the same and only skin tells the difference'. It is the single centralised image of a popular culture object that, because of its bland accessible unimportance can, and does, stimulate the creative imagination.

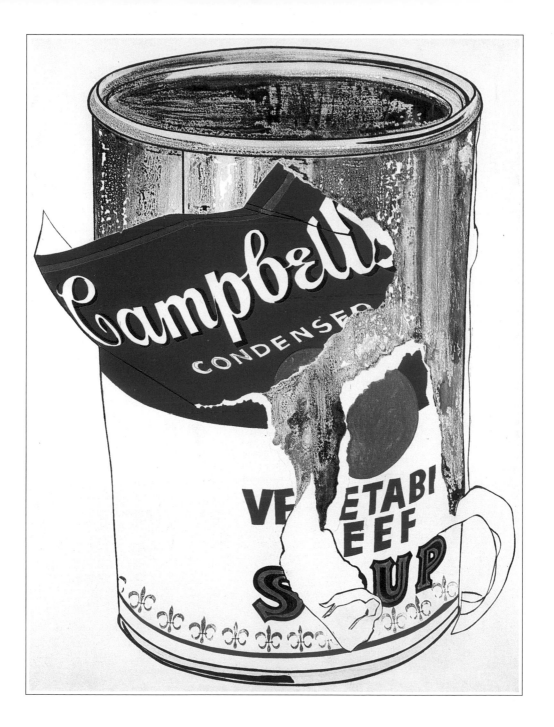

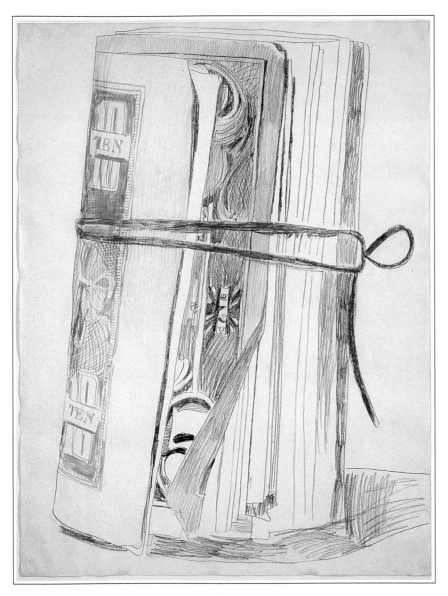

◁ **Roll of Bills** 1962
Pencil, crayon and felt tip on
paper

MURIEL LATOW ASKED WARHOL
what he loved most. He said that
he didn't know and would she tell
him. She then said 'Money, you
should paint dollar bills'. This
sponsored another early series of
works. The way in which Warhol
used the subject was similar to that
of soup cans. A deadpan depiction
of one or more dollar bills. But of
course the dollar has more
significance than the soup can
and, in a materialistic society, is a
sacred symbol of success – a
gateway to all the soup cans and
cokes in the world. The image
here is unusual in that it is a
personalised bank roll and drawn
in a pictorially graphic style – a
life drawing of somebody's money.
It is 'art', indeed another still life
for our time, not only with a
personal identity but with a drawn
cast shadow making it a really
solid bundle.

## ▷ **Front and Back Dollar Bills** 1962

HERE THE DEADPAN IMAGE HAS much to say. This is not just dollar bills flat on a surface but an 'artistic' working of them in which great variation between the bills occurs. The value of the money is the value that the artist, or more probably the dealer, places on it. Thus, in the first instance the artist questions the real value of money. But in placing them in this regular pattern grid he is producing a textured pattern reducing money to wallpaper design and adding another element of complexity. Yet again, since most people value money not for itself but for what it may buy, Warhol is questioning the materialist transference motivation that is inherent in money and what one should do with it – idolise it or spend it?

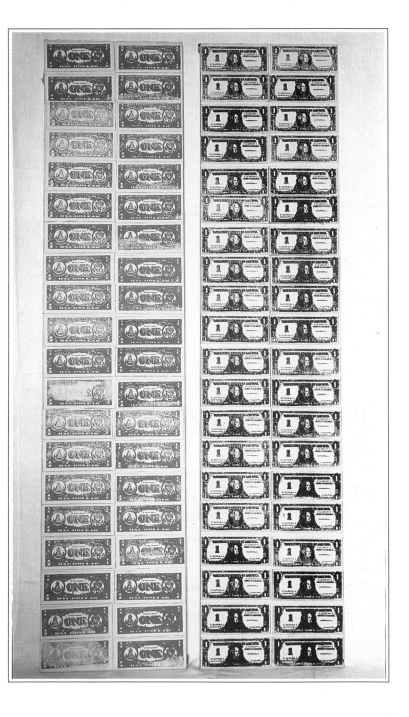

*Detail*

▷ **Before and After** 1962
Graphite on paper

WARHOL HAS AN ALMOST
UNCANNY ability to find potent
images unrecognised as such by
others. The popular form of
advertising known as 'Before and
After' is used to suggest a number
of interlocked aspects of human
nature. The first and most obvious
is that vanity and pride are
features of human weakness. One
image looks better – but which? It
would certainly not be universally
agreed about what constitutes
perfection. One nose perhaps
suggests strength, character and
individuality, and the other
cheerful insouciance and
friendliness, but it would be
difficult to transpose the images.
The painting is so straight-
forwardly anonymous that the
significance of the variation of
the details may be overlooked, but
it is worthwhile to recognise that
there is a seemingly deliberate
difference in the details of hair
and eyes. For instance, the
eyelashes are deftly delicate on the
right-hand face while on the left
they are coarsely divided. It is also
interesting to note that Warhol
himself had an operation to
improve his own nose.

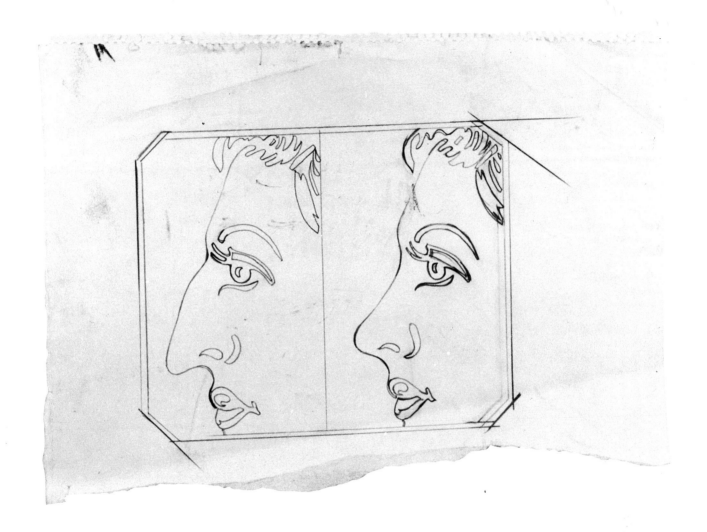

*Detail*

▷ **Most Wanted Men No. 12, Frank B.** 1964
Silkscreen ink on gesso on canvas

DURING 1962 A CHANGE IN ATTITUDE to his subject matter can be seen in Warhol's work. The essentially uninvolved presentation of commonplace artefacts in a deadpan technique gave way to an artistically committed and near-political observation of a different aspect of the American materialist consumer society. It appears to have emerged after a conversation with his friend Henry Geldzahler, during which Geldzahler suggested that soup cans and coke bottles did not represent all of America. Violence and death presented another face, and Geldzahler showed him the morning paper to make the point: '129 die in Jet'. This notion inspired several new series of social comment, crime and disaster paintings. Asked by the architect Philip Johnson to provide a mural for the New York State Pavilion at the 1964 New York World Fair, he provided a large mural, *Thirteen Most Wanted Men*. Again he raises questions without asking them – villains or heroes? Popular anti-icons? A dreadful warning? Public information shots?

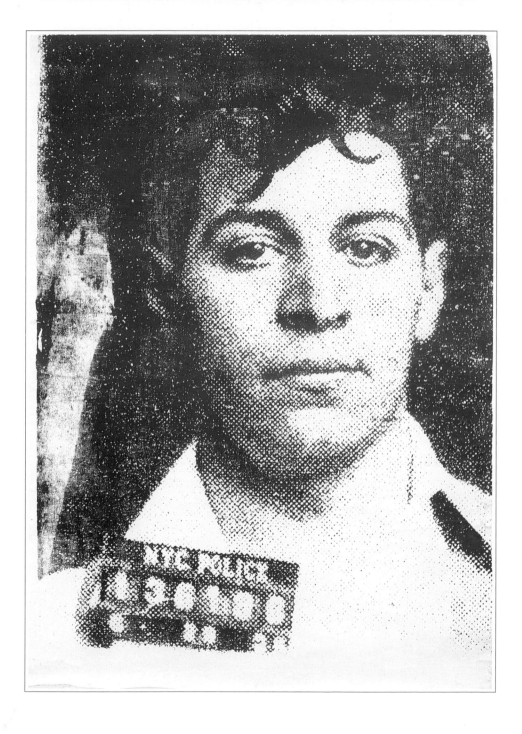

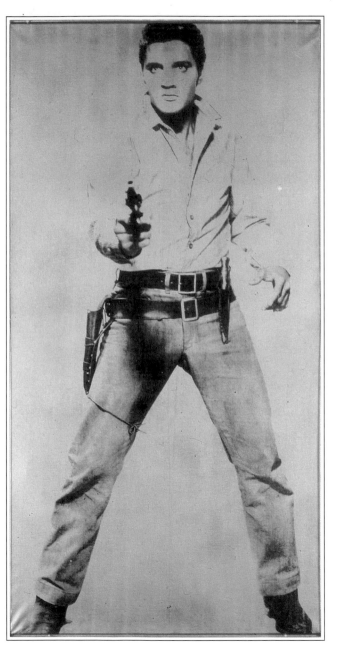

◁ **Single Elvis** 1962
▷ **Triple Elvis** 1962-3

MODERN PERSONALITY CULTURE
REFLECTS a temporary, sometimes
even permanent, transference of
identity from the doers across to
the watchers in a form of wish
fulfilment. The cinema has been
responsible for an escalating
escapist re-identification much
wider and varied than in any
previous age. The creation of
popular icons from all levels of
society and all social activity has
been further extended by the
immediacy of television. Warhol,
with his acute sense of common
values already noted, discerned in
the 'pop' images of film stars and
other public performers the
opportunity to comment visually
on the nature of portrait painting.
The early 19th century mystic
painter William Blake once asked
'Of what interest is it to the arts
what a portrait painter does?'

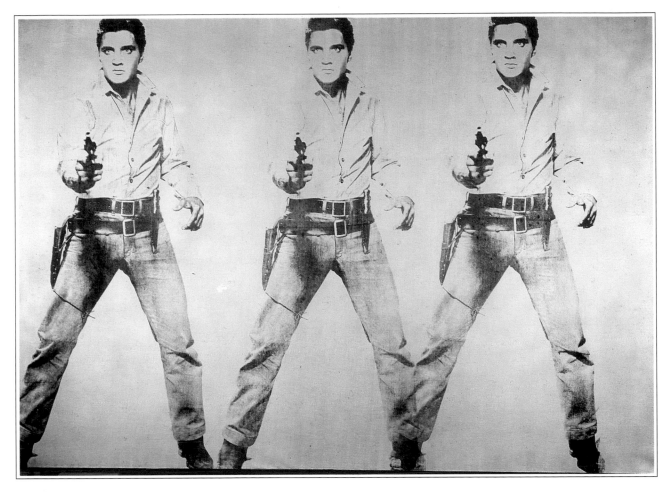

Warhol is taking the constructed personality of the filmic shadow to ask a similar question about the reality of the portrait image. Here, one of the great icons of the period, Elvis Presley, a 'pop' singer, is transformed into an heroic, clean-cut version of the gunslinger and in an image which is divorced from any context. Where is reality and what is being offered in these paintings?

The two works shown here were included in an exhibition in Los Angeles in 1963 and had been cut from a long roll of the same image that he had made in the previous year. In January 1962 it had been suggested to him that he could introduce great labour savings by using photographically based silk-screen methods. Both the *Single* and *Triple Elvis* are reproduced by this method on a silver-coloured paint base which, of course carries suggestions of the Silver Screen.

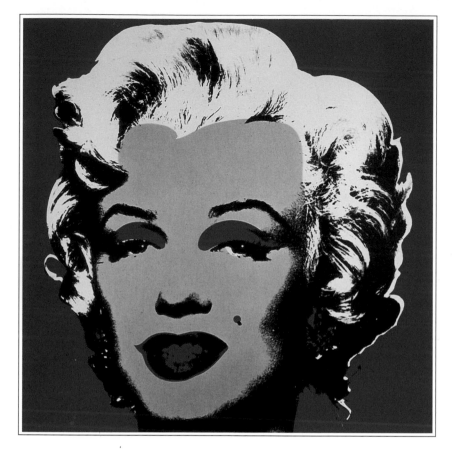

△ **Marilyn Monroe** 1967
Print

ONE OF THE MOST POPULAR of
Warhol's film star images was
Marilyn Monroe. She was the
pre-eminent glamour star whose
fascination continues to this day.
It would have been surprising if
Warhol had not seen Marilyn as
an heaven-sent subject for golden
treatment but, as it happens, it
was the tragedy of her death in

August 1962 that inspired him to
turn to her as a subject. It was at a
time when, prompted by Henry
Geldzahler, he was considering
different aspects of the American
way of life. From this came a
number of series subjects which
reflected the violent energy of
destructive forces in society.
These series of works, generally

described as his '*Disasters*' (pages
34-47), came into poignant focus
with the coincidence of Marilyn's
garish, mysterious and tragic
death at a time when she was the
epitome of the Screen Goddess.
The subsequent revelations about
the private agony and dark depths
of her off-screen life only serve to
add another level to the
significance of Warhol's paintings
of her, and reinforce the truth of
the comments made about Presley,
in *Triple Elvis* (page 25).

Marilyn as a subject also came
at the time when Warhol was
beginning the use of silk-screen
printing. The result was a mixture
of painting and printing for the
Marilyn series. The four examples
shown illustrate something of the
range of possibilities within the
method – most of Warhol's own
invention. His most usual method
was to lay a colour hand-painted
base using a photo template.
Over this he printed a silk-screen
photographic image. The method
allowed him to make a number
of subtle variations to each
painting – and quite quickly.
Through under- or over-inking the
screen and making small changes
in the colour mix dramatic
differences could be achieved in
the final print.

In the first single image (left), the
now famous publicity photograph
for the film *Niagara* which Warhol

△ **Marilyn Monroe** 1962
Painting

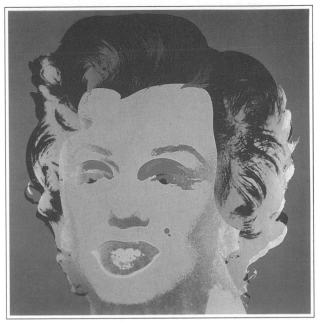

△ **Marilyn Monroe** 1967
Print

used for all the Marilyn paintings, the treatment is more or less straight-forward. The background, the upper eyelids and the lips are ruby red, the hair like corn and the photographic overlay harsh and contrasty. It is an aggressive iconic image

recalled in 1967, five years after her death. The potent memory of the pathos and mystery of Marilyn's death with the long-lived speculation surrounding it elevated her to the greatest modern star status. Warhol's paintings participated in the public

consolidation.

The earlier *Marilyn Diptych* (1962) (pages 28-29) reflects more effectively the multi-layered emotion which followed her death. Historically the diptych,

*continued overleaf*

*continued from overleaf*

composed of two hinged panels, is a religious object usually carrying an image of the Madonna on one side and that of a saint on the other. Warhol was an intellectual and reflective painter despite his reputation as a laconic lightweight, acquired through his association with 'Pop', and it might be added, his own efforts, and the implications of a diptych were undoubtedly deliberate; after all, she was a goddess. The colour pattern on the left-hand panel is strident and unnatural, exaggerated and totemistic as it might be in a medieval diptych and the multiple imagery evokes the ubiquitous influence of the mass media. The right-hand panel is more complex. It should be realised that the variations of tone and clarity are deliberate and, in the method used, could easily be avoided. The imagery fades from left to right, in the first vertical column a generally clear image, in the second a dark pall appears and in the remaining three the image fades. A parable of Marilyn's unhappy private life in strong contrast to her colourful, joyful public personality. In *Gold Marilyn Monroe* (page 27) the image is centralised on a gold ground and

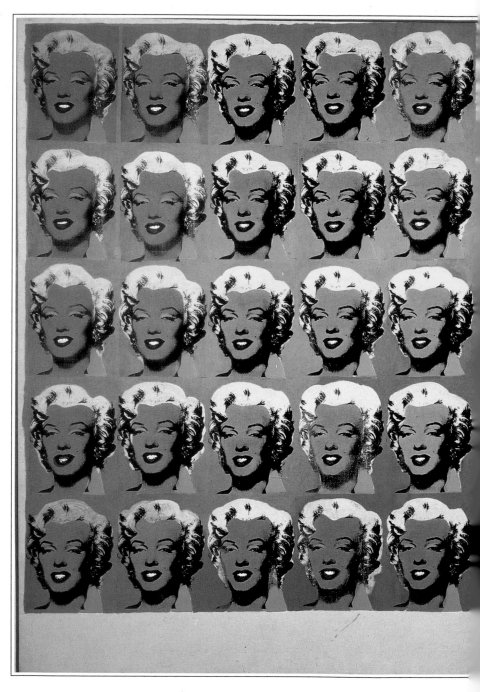

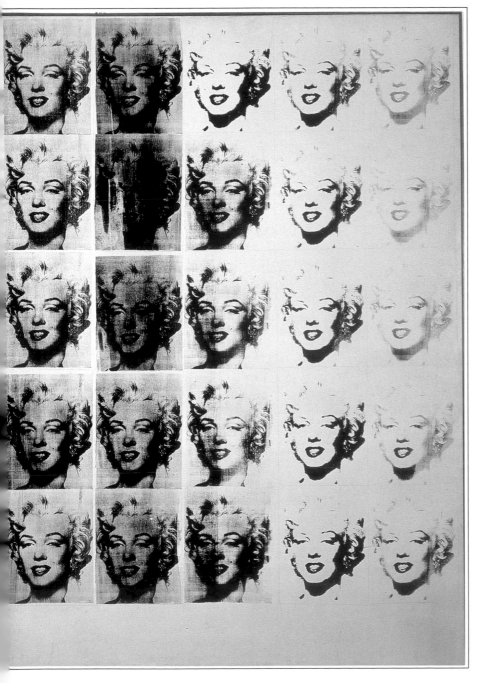

again a religious icon is implicit. Finally, in the first and third images (pages 26 and 27), from the edition of prints made in 1967, Warhol explores what in the textile trade would be called colourways. This, one of ten colour variants, none of which have natural colour, is more an exploration of colour relationships which, although they may suggest different aspects of the Marilyn character, are in fact a commercialisation of her iconic popularity.

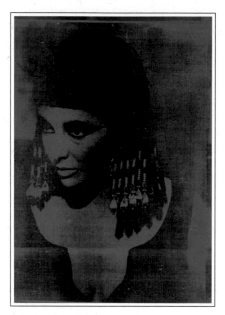

*Detail*

▷ **Blue Liz as Cleopatra**
1963

ELIZABETH TAYLOR WAS A CHILD
star who grew into a screen idol of
great beauty with a private/public
life of quite remarkable variety. In
this multiple silk-screen painting
Warhol depicts her as Cleopatra
in the infamously over-budget film
she made with Richard Burton.

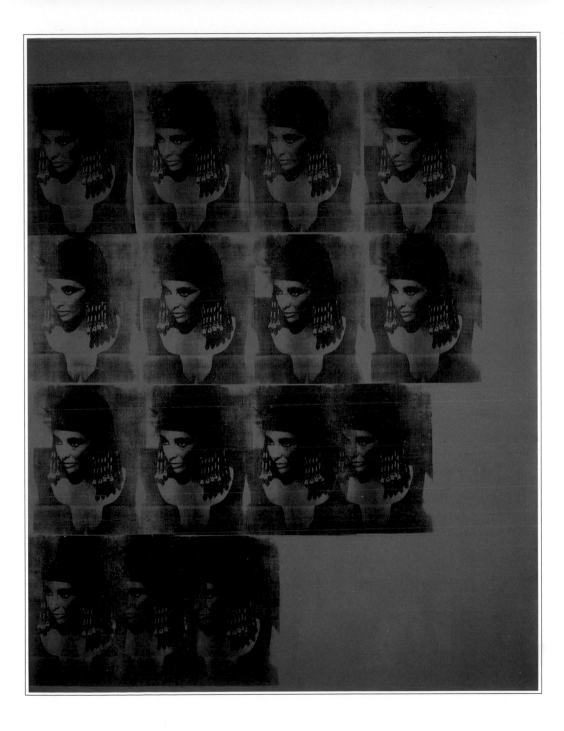

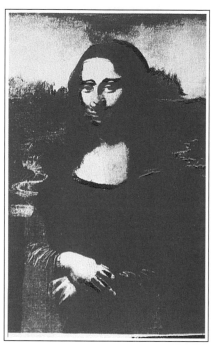

*Detail*

▷ **Mona Lisa** 1963
Silkscreen ink and synthetic polymer paint on canvas

ALWAYS IN PURSUIT OF A POPULAR icon to subject to his processes of reinterpretation, the *Mona Lisa*, the most famous painting of Western art, came as a natural to Warhol when it was exhibited at the Metropolitan Museum, New York in 1963. This attracted so much media attention that the *Mona Lisa* print industry flooded the market with millions of prints, large and small, good and bad. The painting carries many levels of historical association and although Leonardo da Vinci actually painted a Florentine woman of the Renaissance the painting has acquired a spiritual aura and is sometimes confused with the Madonna. Warhol, bearing in mind the print industry, has reduced the *Mona Lisa* to a printing process, by producing a printer's test sheet image and an abstract 'art' pattern in combination. The colour printing process uses four colours only to achieve the full range – black, red (magenta), yellow and blue (cyan). In printing it is common practice to use one sheet to test randomly with the different base colours, and it is this effect that Warhol has used, turning it into a carefully arranged pattern and in effect taking the *Mona Lisa* apart, revealing the mechanical basis of the print.

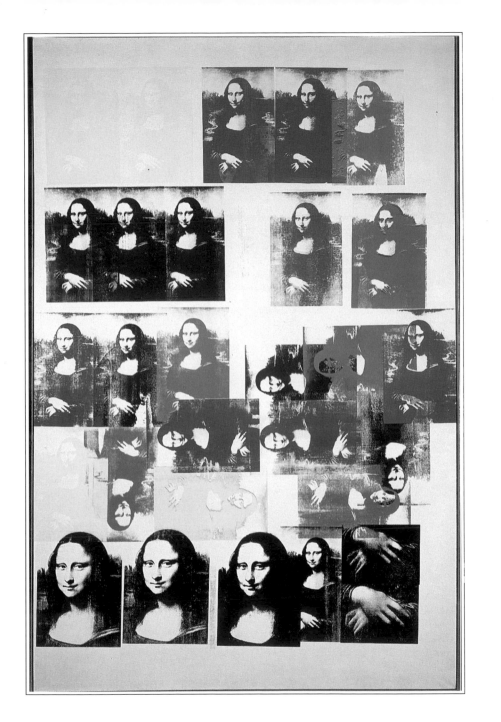

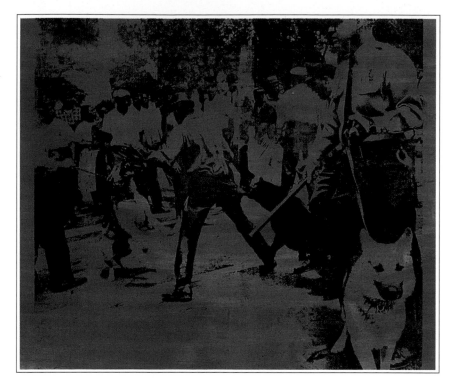

*Detail*

## ▷ **Red Race Riot** 1963

'MAYBE EVERYTHING ISN'T SO fabulous in America. It's time for some death'. Henry Geldzahler made this observation over lunch with Warhol and it became the inspiration for a wide range of work from 1963. In May of that year racial tension in the south led to black civil rights riots and at the end of the year President Kennedy was assassinated. These events made Geldzahler's point and together with Marilyn's death and other tragic contemporary events they convinced Warhol that there was new and significant subject matter in disasters. He has explained that the disaster paintings were in two parts: the famous; and the unknown, such as the suicide girl who jumped from the Empire State building in 1947. Such subjects produced his most powerful and disturbing images. As he commented, 'I thought it would be nice for those unknown people to be remembered'. *Red Race Riot* repeats three photographs of police with dogs in a civil rights protest in Birmingham, Alabama, in May 1963. The genuine fear, anger and antagonism felt by both sides is given extra emphasis by the suggestion of blood in the overall textured red tint.

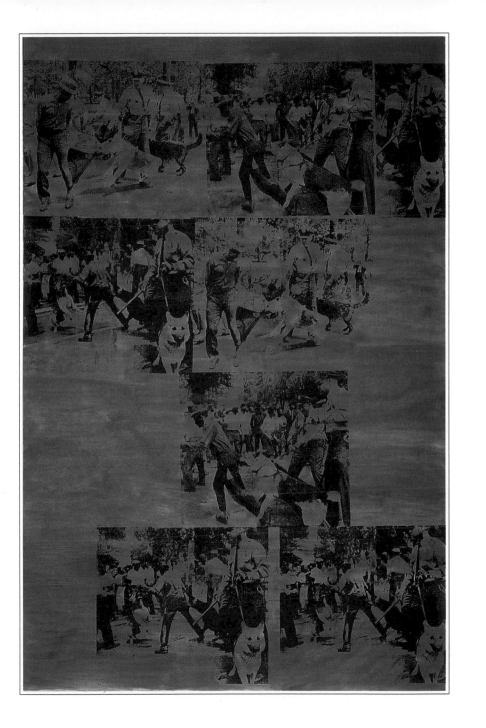

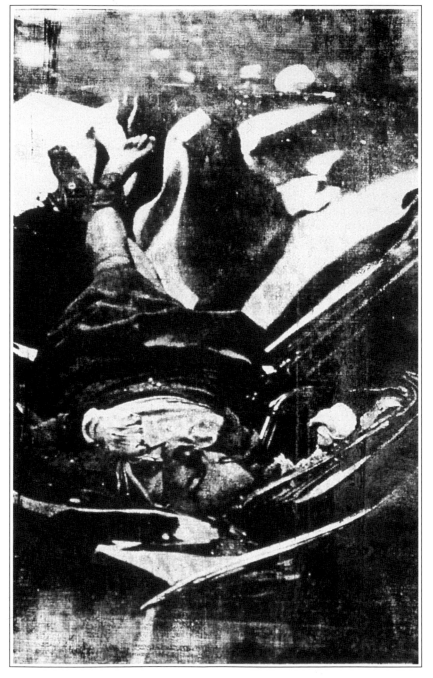

▷ **Suicide (Fallen Body)** 1963
Silkscreen ink and synthetic
polymer paint on canvas

THE REPEATED IMAGE OF THE
BODY of a suicide, crumpled,
twisted and almost unrecognisable
within the near-abstract forms
surrounding it, presents one more
disturbing vision of disaster. This is
Warhol remembering the
unknown – and perhaps
unknowable. A seemingly
universal curiosity about death
draws people to such happenings
and the heads of observers can be
seen at the top of each image. This
is the poignant finale to a process
which began from a high window
ledge. Warhol, in his suicide series,
has produced pictures of several
stages in the process, each in the
form of multiple images. In this
expressionist picture the harsh
complexity of shapes recall the
paintings of El Greco.

*Detail*

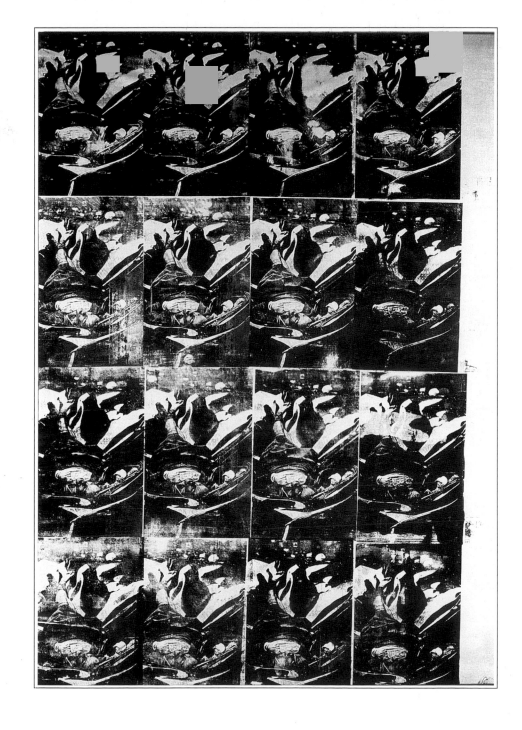

△ **Big Electric Chair** 1966

A MORE INTENSE SOLID red background in this painting than is found in *Red Race Riot* suggests the more horrifying institutionalised and formally observed death that is represented by the *Red Electric Chair*. Warhol ·painted a number of versions of this subject in 1963, when New York State abolished death by electrocution. His bland treatment of this symbol of ritual death and retribution, seen from the viewpoint of the officials who attend, nevertheless evokes many complicated layers of emotion. The chair has become an historical symbol to which many viewers must have had ambivalent responses – some at least must have wondered if the discussed chair would become a symbol of increased violence and crime. It is another example of Warhol's ability to single out a potent multi-layered subject.

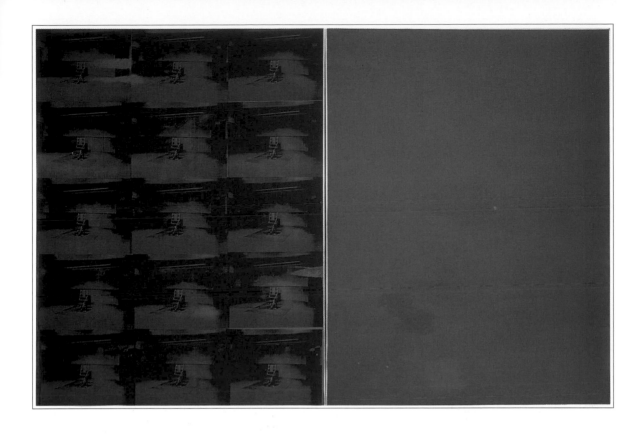

△ **Blue Electric Chair** 1963
Synthetic polymer paint and silkscreen ink on canvas

In a number of his paintings Warhol uses a solid colour ground panel alongside a single or multiple image of his subject. In this example the same photograph of the Electric Chair which appears in a single image with a red ground (opposite) is repeated fifteen times in conjunction with a clear blue panel containing familiar suggestions of colour association – sky, space, freedom – in strong contrast to the background blue of the muddy dark overprints and their sense of menace and foreboding.

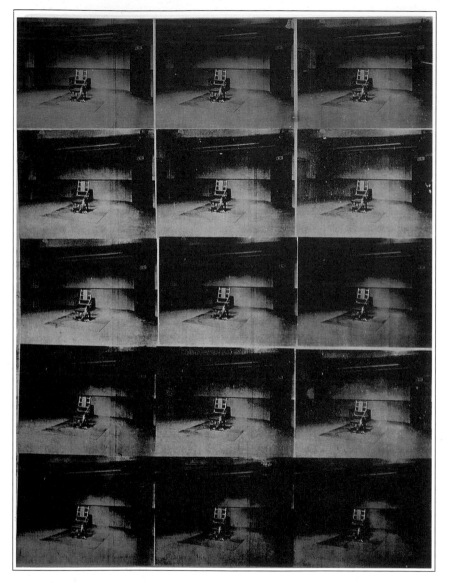

◁ **Lavender Disaster** 1963
▷ **Orange Disaster** 1963
Synthetic polymer paint and
silkscreen ink on canvas (both
images)

WARHOL'S DISINTERESTED
OBSERVATIONS or 'cool' technique,
sometimes in single and
sometimes in multiple images, has
been noted as appropriate to a
number of the works illustrated.
The disaster illustrated here is
reproduced in his photo-
mechanical silk-screen process and
is another example of repeated
impact. It is appropriate to recall
Warhol's comment that when you
see a gruesome picture over and
over again it really doesn't have
any effect. Lavender, the back-
ground colour on this page, has
subjective connotations of death,
memory, and the fading of colour
from purple, a strong colour, to
lavender, weak and smelling of
decay. However, *Orange Disaster*
shown opposite, casts a lurid
orange light reminiscent of the
heat and shock generated in the
moment of electrocution by the
electric chair.

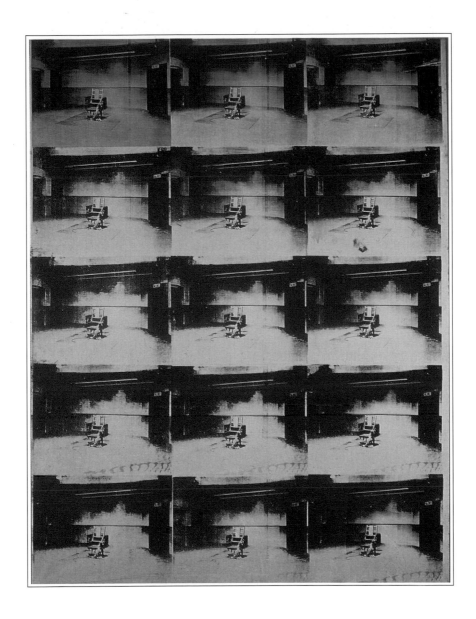

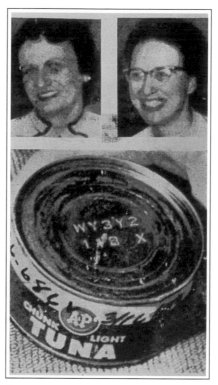

*Detail*

▷ **Tunafish Disaster** 1963
Synthetic polymer paint and silkscreen ink on canvas

WARHOL'S RECOGNITION OF THE IMPACT of multiple frames in the building of emotional tension, attracting concentration and activating a compulsive consideration, is well evidenced here. The repetition of tuna cans, with photographs of the two women who died of botulism as a result of eating from those cans, has provoked a reminder that it could have been us. The victims look happy – as if they had won a lottery – instead of having lost one.

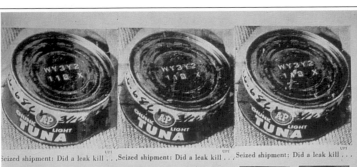

Seized shipment: Did a leak kill . . . Seized shipment: Did a leak kill . . . Seized shipment: Did a leak kill . . .

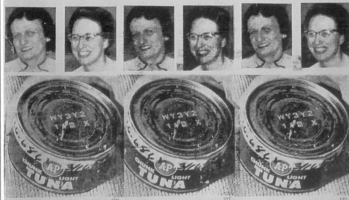

Seized shipment: Did a leak kill . . Seized shipment: Did a leak kill . . Seized shipment: Did a leak kill . .

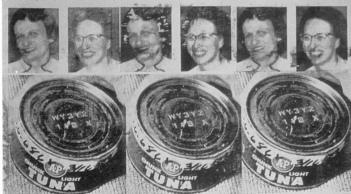

Seized shipment: Did a leak kill . . . Seized shipment: Did a leak kill . . Seized shipment: Did a leak kill . . .

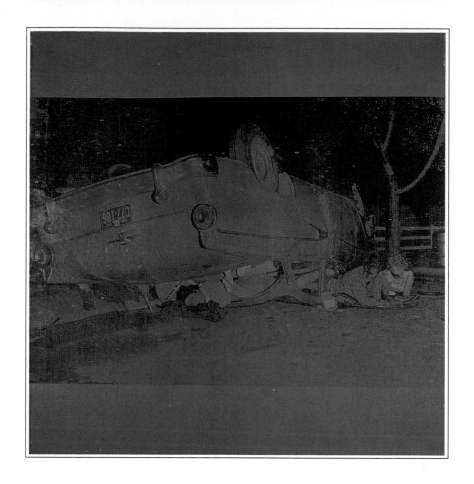

△ **Five Deaths on Orange**  1963
Synthetic polymer paint and silkscreen ink on canvas

AFTER THE APOCALYPTIC
UNIVERSALITY of the atomic
bomb's indiscriminate death-
dealing capacity, the single image
of a fatal car crash brings the
personal nature of disaster into a
different focus. It is particularly
poignant that two of the victims
are conscious and looking at the
body of the third. The survivors
have to live with the memory and
now so does the observer, who has
a personal and intimate view. This
is essentially a 20th century
disaster of the machine age, of the
automobile, a designed form of
pleasure and utility that acts as the
angel of death. Warhol has
heightened the dramatic effect
by casting a lurid orange light
over the otherwise dark and
hushed scene.

## ▷ **Saturday Disaster** 1964
Synthetic polymer paint and
silkscreen ink on canvas

LIKE *FIVE DEATHS ON ORANGE*,
1963, *Saturday Disaster* uses a
photograph of a car crash. In *Five
Deaths on Orange* only one car
appears to be involved, probably
on a pleasure trip. In this painting
more than one car is involved and
the scene seems even more
horrific. There is a chaos of
twisted and trampled figures
which are difficult to disentangle.
The double image reinforces the
confusion, and the density of the
black and white contrast
emphasises the abstract pattern of
death and disaster. Saturday is a
weekend holiday, a shopping and
pleasure day, and although no
doubt the crash actually happened
on a Saturday the inclusion of that
day in the title adds that extra
layer of meaning.

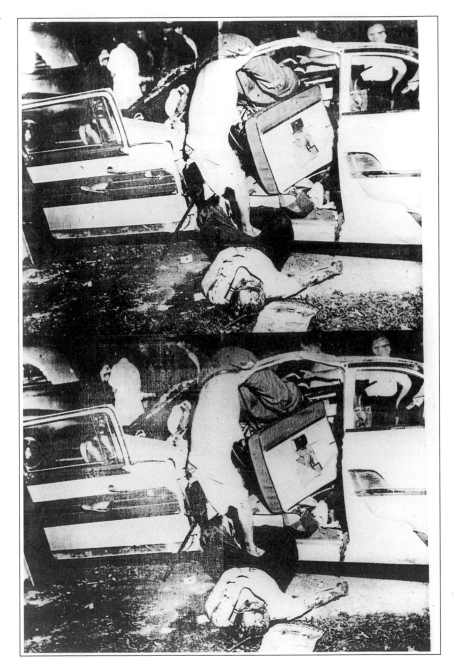

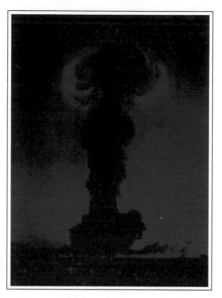

*Detail*

▷ **Atomic Bomb** 1965

A MORE POTENT EXAMPLE of the efficient human pursuit of death and disaster could hardly have been chosen. In this multi-image (silkscreened) painting Warhol has used the technique to make an observational point. Again the red background pervades the scene, the same appropriate symbol of blood, and the progression to annihilation and black oblivion is revealed by the succession of images from top left to bottom becoming increasingly darker and more indistinct. It is difficult to believe Warhol's cool assertion of personal uninvolvement in his subjects in this instance, since in the 1960s the threat of the bomb at the height of the Cold War was real to everyone, a constant presentiment of death.

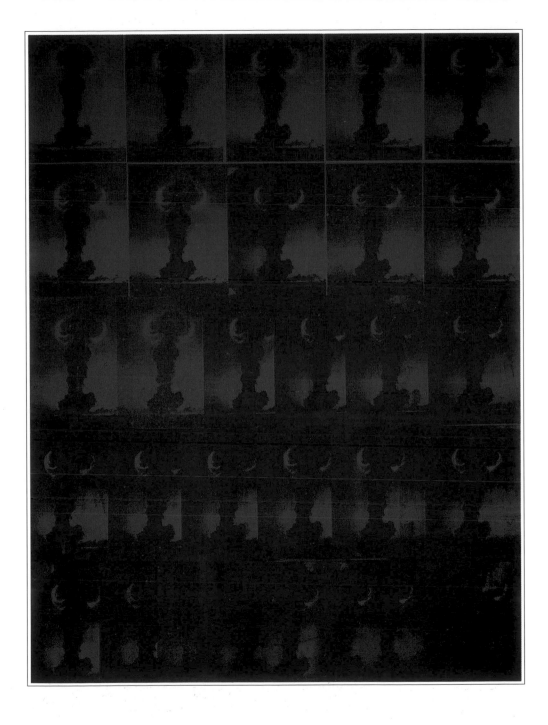

*Detail*

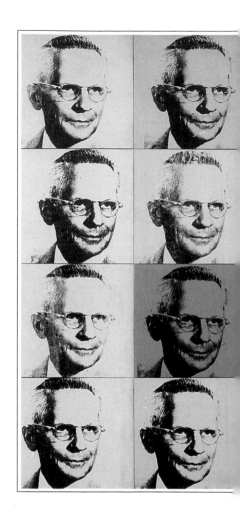

▷ **The American Man (Watson Powell)** 1964

WATSON POWELL WAS THE PRESIDENT of the American Republic Insurance Co. of Des Moines, Iowa, and this photograph of him was used for publicity purposes, presumably in the belief that Powell gave the right image of probity, intelligence, keen business sense or whatever the insurance industry deemed desirable. The multiple image, with slightly different-coloured backgrounds, suggests that there are many such men, interchangeable and anonymous – but all reliable. Warhol's title, *The American Man* indicates not only that identical replication is the norm but also that success in business is the ultimate goal.

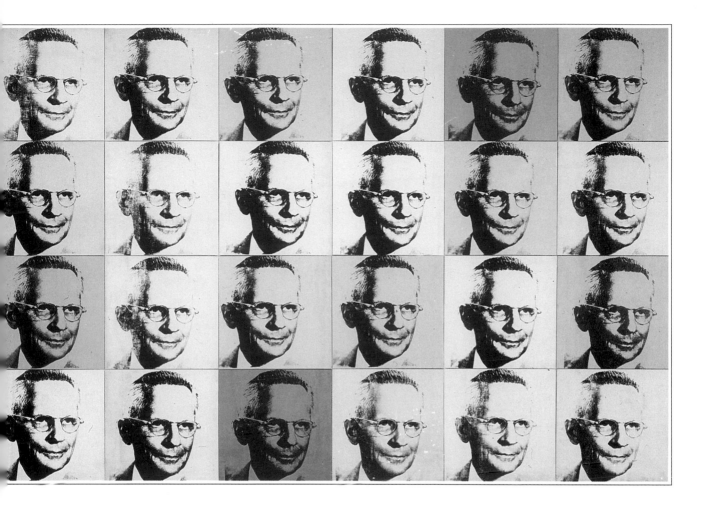

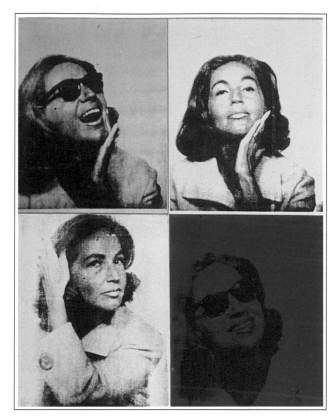

*Detail*

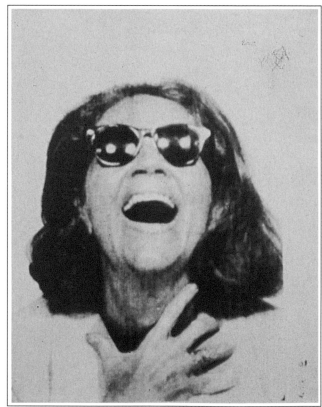

*Detail*

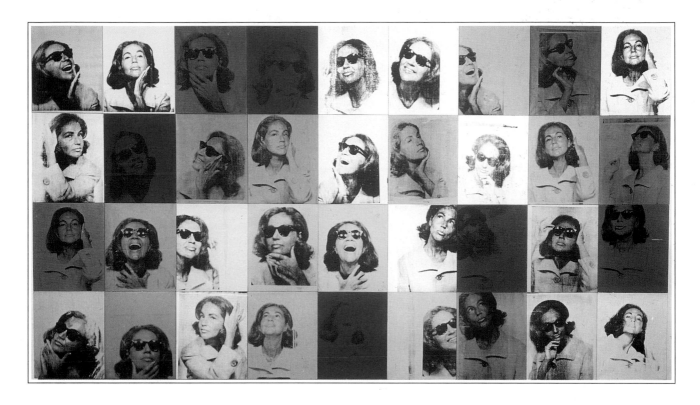

△ **Ethel Scull 36 Times** 1963
Synthetic polymer paint and silkscreen ink on canvas

NOT SURPRISINGLY FOR ONE WHO wanted to have a minimum visible individual input, commissioned portraiture was not attractive, and this portrait of Ethel Scull, the wife of a New York taxi company owner who was also a collector of modern art, is Warhol's first such commissioned portrait. The photographs that form the basis of this multiple were taken in photo booths and subsequently grouped together, a number repeated several times. In this way the formal single image was replaced by a range of views which enlarge and reveal different aspects of Ethel Scull's character, emphasised by the changes in colour grounds. She is reported as liking the result and commenting that it was a portrait of being alive and not like those candy box things…

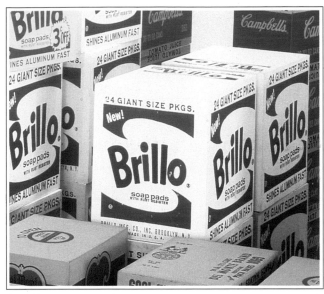

*Detail*

▷ **Various Box Sculptures**
1964
Synthetic polymer paint and
silkscreen ink on wood

WHEN WARHOL PRODUCED HIS
various box sculptures it was
believed by the popular press and
general public that he had merely
acquired a quantity of Brillo pack
containers and was exhibiting
them in a New York gallery, piled
high as might have happened in a
stockroom. But this is far from the
facts. Possibly inspired by Claes
Oldenburg's enlarged plastic
versions of domestic artefacts,
Warhol, with his assistant and a
team of carpenters, had a number
of wooden boxes made (over 400
in total for different products) on
which the designs of Brillo and
other product packs were silk
screened. He was not therefore
exhibiting 'readymades' but
sculptures which, whatever value
might be placed upon them by
others, were as valid as, say a
horse or nude in bronze or stone.

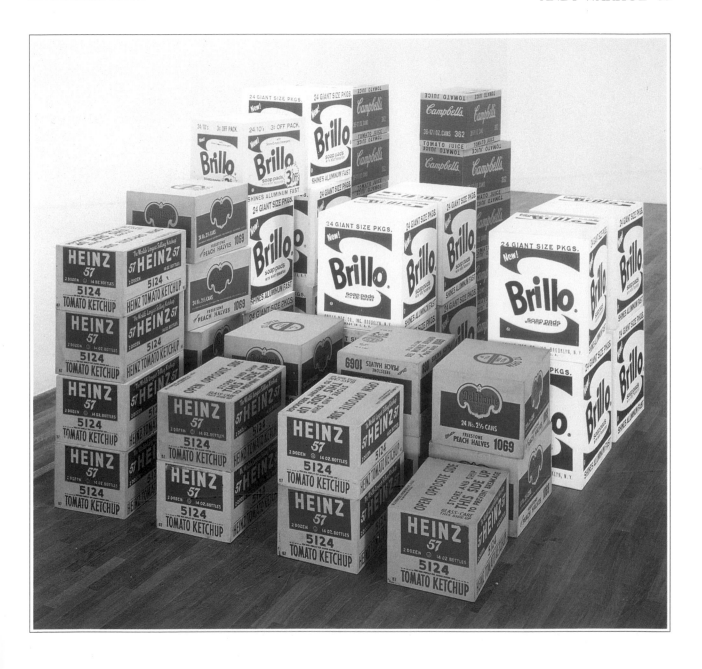

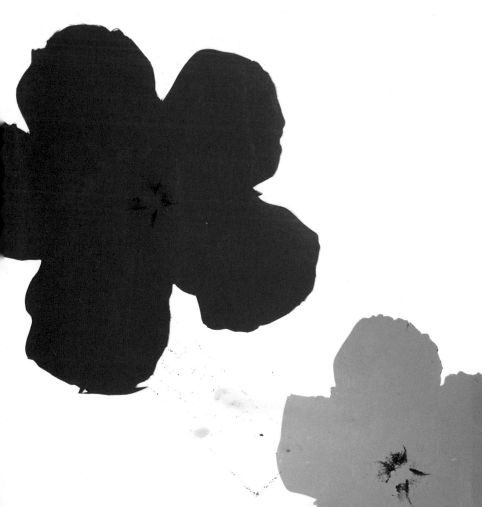

## ▷ **Flowers** 1964

IT WAS HENRY GELDZHALER, his friend and art critic, who in 1962 redirected Warhol from soup cans, coke bottles and film stars into the disaster theme. In 1964 he again advised Warhol, this time to leave disasters and paint flowers instead – a dramatic change indeed and one that Warhol adopted with enthusiasm. During that summer, with his assistant, Gerard Malanga, several hundred paintings were produced in a variety of colours. The first exhibition in November 1964 at Leo Castelli's gallery sold out and the industry continued. Geldzahler's suggestion had paid off but, of course, it was Warhol's ability to transmute a casual suggestion into powerful imagery that was significant. Flowers are attractive and used for many purposes including in remembrance on graves – Warhol's tribute to the dead disaster theme perhaps.

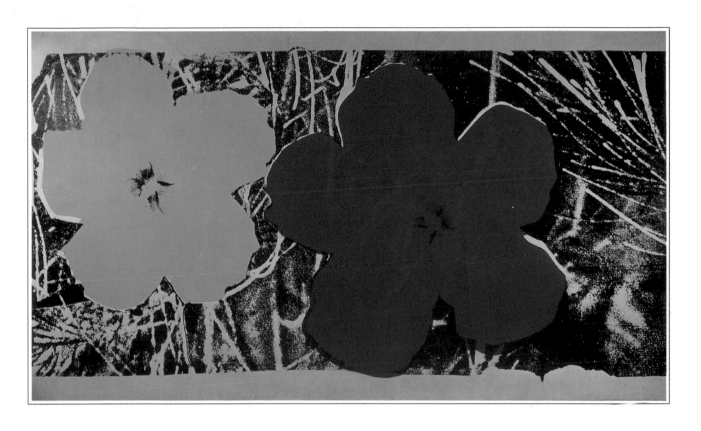

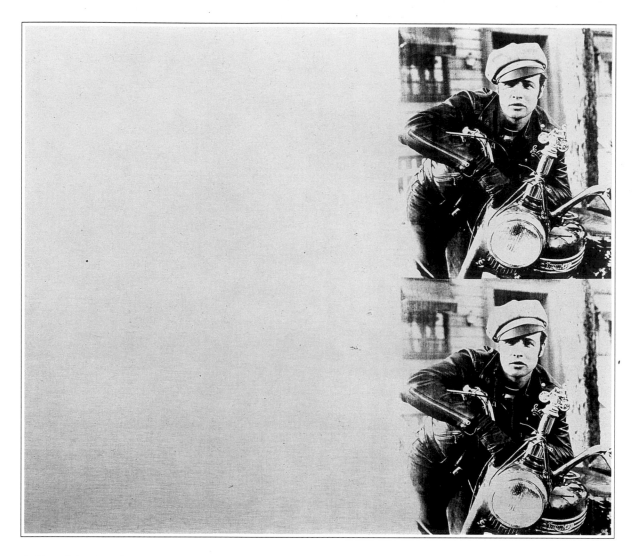

△ **Double Marlon** 1966

IN THE FILM *THE WILD ONE* (1954) Marlon Brando played the role of leader of a leather jacketed gang of anarchic motor cyclists. As a method actor, mumbling his lines in broken sentences and with dismissive or aggressive grunt signals, he represented an aspect of American culture that naturally attracted Warhol. Firstly, Brando was at this time a young icon, an anti-hero film star in the James Dean mould, and secondly he represented, as Johnny the cyclist leader, the breakdown of law and culture among the young. In this double image screen print the raffish figure is close to the right

edge while the remaining two-thirds of the canvas is unpainted. Warhol has chosen a still in which Brando is looking into the empty space (possibly symbolising a blank hopeless unknown future). This device of empty space is used by Warhol frequently and gives, as he might have said, 'room for thought'. The double image suggests the film strip and the unreal world of celluloid.

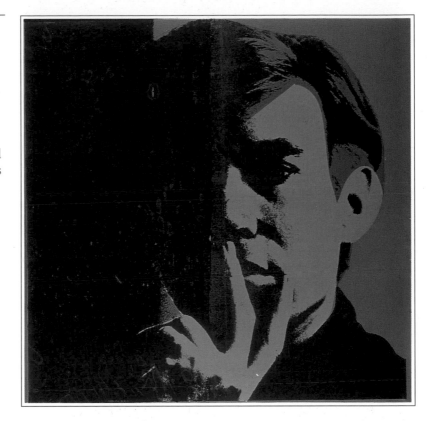

△ **Self-portrait** 1967

BY 1966 WARHOL'S INTEREST in making films was beginning to replace his artistic output and his career was in any event in the doldrums, not helped by the unsuccessful *Cow Wallpaper* (page 60) show. During this time he painted a number of self-portraits, using a photograph taken when he was a young man. As he himself recognised, he had become one of his own icons, and these portraits were treated with variety of colour patterns in single and multiple images which in due course came to be among his more popular paintings. The fact that he chose a photograph in which the left-hand part was obscured so that he seems to be only partially revealed is unlikely to be mere coincidence. Half of his life was very private, and his homosexuality, although known, was not publicly expressed. Even more significant perhaps is his deliberate determination to disguise his intellectualism behind his public fresh youth image. Nevertheless he presents a thoughtful reflective expression.

▷ **Cow Wallpaper** 1966
Screenprint printed on wallpaper

WARHOL'S UNDOUBTED GENIUS lay
in his ability to transform the
obvious and the mundane, the
throwaway notions that he caught
from his friends, into potent,
compelling and suggestive
paintings which awakened viewers'
imaginative faculties. An example
of this ability came from a
suggestion that contemporary art
was unfortu-nately no longer
concerned with the pastoral scene
which had been so important in
the historical tradition of western
art. The outcome was the cow
wallpaper, which formed the main
part of an exhibition in New York
in 1966. The wallpaper design
consisted of the placid heads of
cows filling the whole width of the
strip, one above another. The
exhibition was not successful.
Nevertheless, the single head of the
cow has a multi-layered impact –
stimulating reflections on the
nature of art, of a field of cows in
the city, on the pastoral tradition
in art, etc. It is interesting to note
that despite the failure of the show
the few rolls of wallpaper still
remaining are now expensive
collectors' pieces.

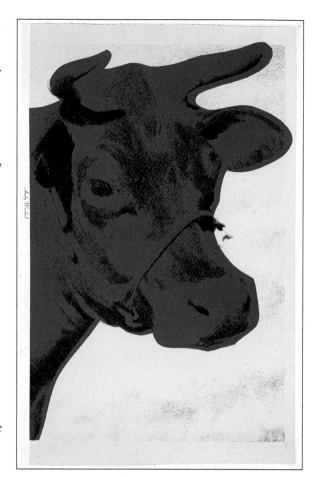

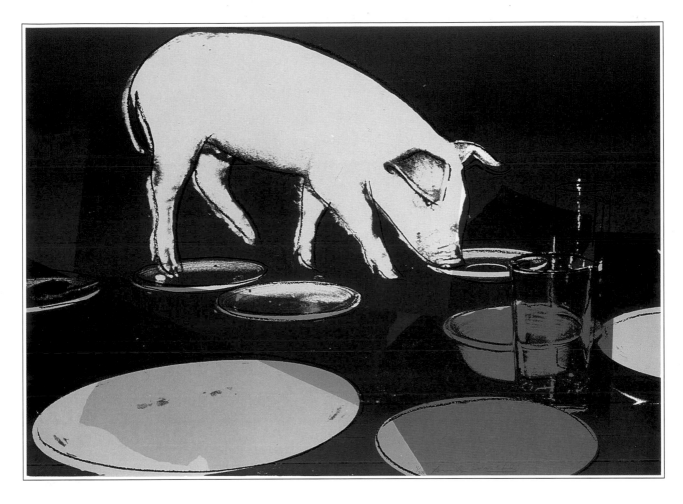

△ **Fiesta Pig** 1979

THE HIGHLY COLOURED FIESTA Ware dishes manufactured during the 1930-50 period were collected by Warhol, an avid collector of kitsch since he first arrived in New York. At his death most of his collection was sold at auction and fetched a considerable sum. The pig was used by Warhol as a prop in a publicity photograph in which he appeared with the pig in his arms. Warhol's approach to subject matter is well illustrated here. He combines Fiesta dishes with a relatively naturally coloured pink pig. A guzzling piglet being loose among such collector's items is an example of the visual games he played in his later imagery.

*Detail*

### ▷ **Julia Warhola** 1974
Synthetic polymer paint and silkscreen ink on canvas

WARHOL'S MOTHER, BORN JULIA Zavacky in Slovakia, was an important if not always sympathetic element in his life, and he lived with her in New York from 1952 almost until she died in 1972. He did not, however, attend her funeral. This portrait was painted two years after she died. It remained with him and must have had some sentimental genesis. There is a 'painterly' manipulated surface, an indeterminate realism which almost destroys the effect of the photograph. It seems a reversal to the 1950s expressionist techniques of his immediate artistic predecessors.

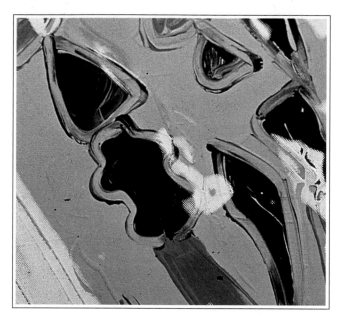

*Detail*

## ▷ **The American Indian: Russell Means** 1976

THERE IS A SLIGHT SLICKNESS and an uninvolving superficiality in this work, which perhaps could indicate that Warhol had, temporarily at least, lost his way. The subject, Russell Means, is a Native American who became known through his publicising the conditions, without full civil rights, in which the Native Americans were still living in 1970.

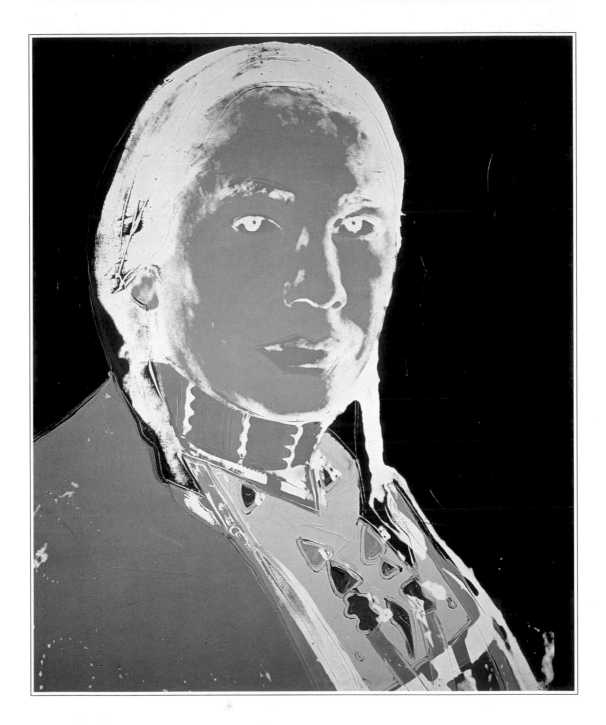

*Detail*

## ▷ **Mao** 1972

MAO WAS ANATHEMA TO THE American public during his lifetime and represented the antithesis of American capitalism. Warhol was aware of the potential of an anti-icon from which responses might be aroused. In treating the portrait of Mao which was used for the frontispiece of Mao's Little Red Book and enlarging it in some cases to over 14 feet (4.3 metres) in height, Warhol created a compulsive image in dramatically unnatural colour. In this example, from the edition of prints, the whites of Mao's eyes give them a benign intelligence which Warhol must have intended. In many of the examples the background colours are added unevenly, whereas in this version he has introduced to flat colour a number of scratched and hand-drawn lines – which also suggest a personal involvement or attraction.

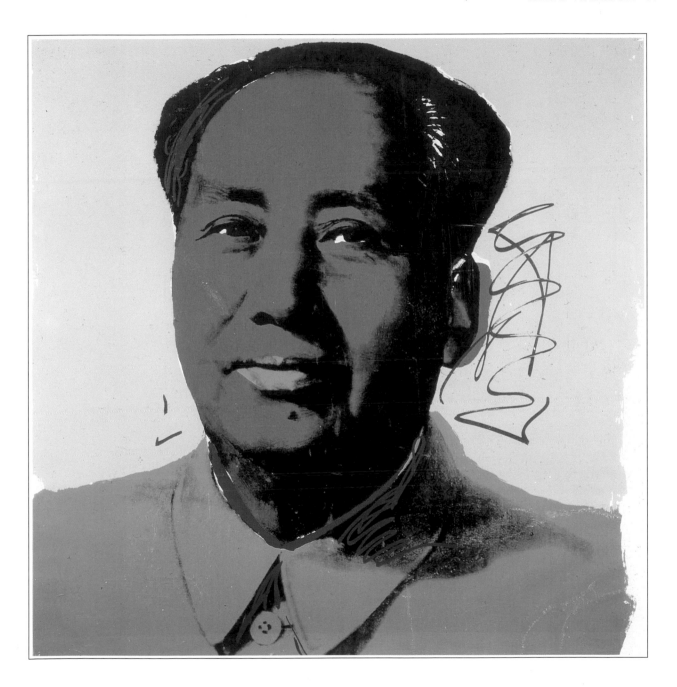

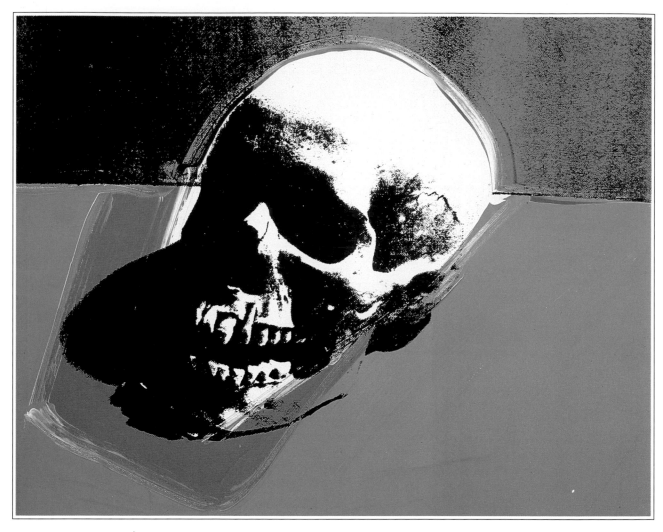

▷ **Skull** 1976
Synthetic polymer paint and silkscreen ink on canvas

THE HUMAN SKULL CARRIES SO many mixed messages that it has a long history in pictorial art, and Warhol, who had bought a skull in 1975 in a Parisian flea market, saw it clearly as a memento. He had survived a shooting attempt in 1968, but was seriously wounded, and eventually died as the result of a later operation on his gall bladder, damaged in the shooting. From this time he was always conscious of the impermanence and insecurity of life and suffered from bouts of depression. His fame was by this time secure and the contrast between mortality and immortality as Picasso

reflected in his use of the human skull, is a curious reversal of reality and illusion. While contemplating the use of the skull as a subject his assistant, Ronnie Cutrone, reminded him that it would be like doing a portrait of the whole human race.

△ **Hammer and Sickle** 1976
Synthetic polymer paint and silkscreen ink on canvas

WARHOL, IN HIS SEARCH FOR AN extension of his artistic language – to find new subjects that could pull him back on the avant-garde track, tried in the 1970s a number of directions while, for financial reasons, reinventing and reissuing some of his earlier images. The *Hammer and Sickle* series is one such and indicates another change in the nature of his artistic attitude.

Like the portraits of Chairman Mao (page 66), and the Native American series, the *Hammer and Sickle* is perhaps chosen because it seems to be using a bland, if exciting, image to stimulate new and unexpected responses in the viewer.

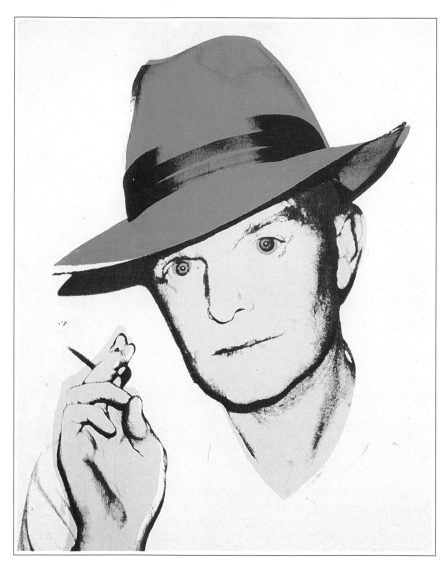

◁ **Truman Capote** 1979
Synthetic polymer paint and
silkscreen ink on canvas

WARHOL AS A YOUNG MAN was
much attracted to and admired
the writer Truman Capote. After
he had settled in New York in
1950 he wormed his way into an
acquaintance which Capote
appears to have done little to
advance. It is clear that Capote
had no great regard for Warhol,
and certainly did not reciprocate
Warhol's feelings. but when
Warhol became more famous and
Capote's alcoholism affected his
reputation and success the tables
were somewhat turned, and
Warhol produced a series of
portraits which helped to bring
Capote again into notice. The
gaunt features and staring eyes,
emphasised in this painting by an
area of colour, show a stressed and
almost despairing character
which is struggling to present an
elegant suave face to the world –
the nonchalant tilt of the hat
helps. This is an affectionate but
ruthless portrait.

▷ **Joseph Beuys** 1980
Synthetic polymer paint and
silkscreen ink on canvas

JOSEPH BEUYS, BORN IN KREFELD,
Germany in 1921 was a painter,
sculptor, conceptual artist, teacher,
performer and, as one of the
founders of the Green movement,
a politician. Warhol has portrayed
him in felt hat with upturned brim
which had effectively become his
uniform – he rarely took it off.
They are similar in one respect at
least – they became very rich
through art. Warhol met Beuys in
New York in 1979 and a few times
later, but they never became close
friends. Beuys quickly appreciated
the layered complexity of Warhol's
work, but Warhol did not have a
correspondingly high regard for
Beuys's work. Warhol was
commissioned to paint Beuys's
portrait and, as usual, made many
different versions.

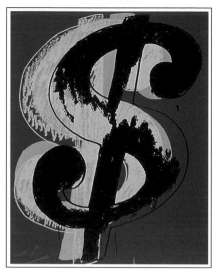

*Detail*

▷ **$ 9**  1982

ANOTHER EXAMPLE OF WARHOL'S indecision and lack of direction at this period. He had lost some of his great creative energy and imaginative enthusiasm and, with a few exceptions, was never able again to produce the extraordinary potent imagery of his earlier years. In an attempt to regain his pre-eminence he reverted to earlier models and *$ 9* echoes the *Roll of Bills* (page 18) in that the hand gesture of the painter is evident in both as distinct from the bland anonymity of, say, the *Campbell Soup* series. The dollar signs are roughly drawn but prettily painted in bright colours.

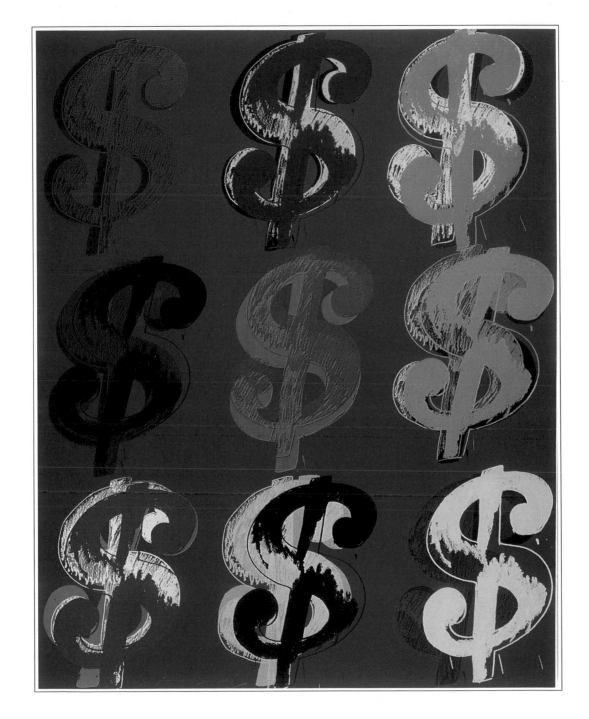

*Detail*

▷ **Life Savers** 1985

IN THE YEAR BEFORE HIS DEATH Warhol made a number of his photomechanical screenprints of commercial ads with some deliberate divergence from the original – some out of register, some in different colour, some redrawn. It was a kind of return to his original career as a commercial artist, but with the difference that he had transformed it into art. He had crossed the final bridge by turning commerce into art by his presence – anything could be art if he said so. Most of the prints in this famous series are of famous or familiar adverts. This one is a drawn interpretation of an actual advertisement.

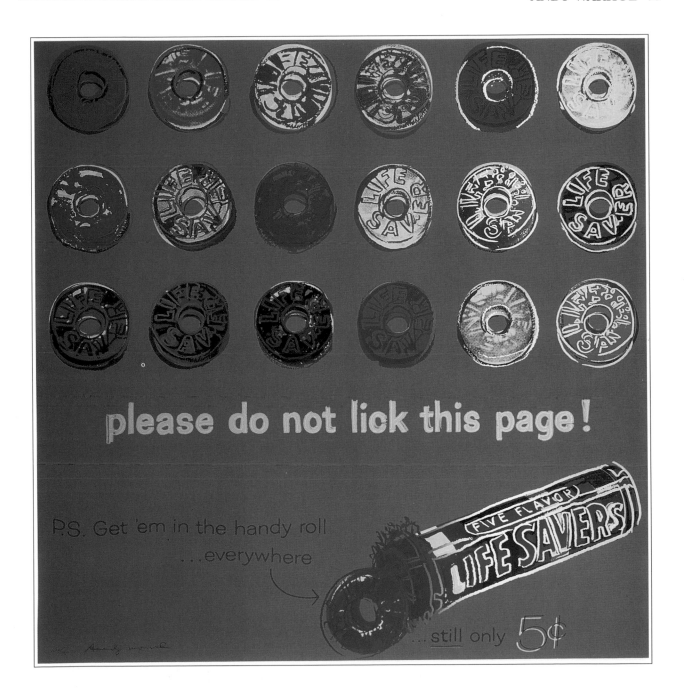

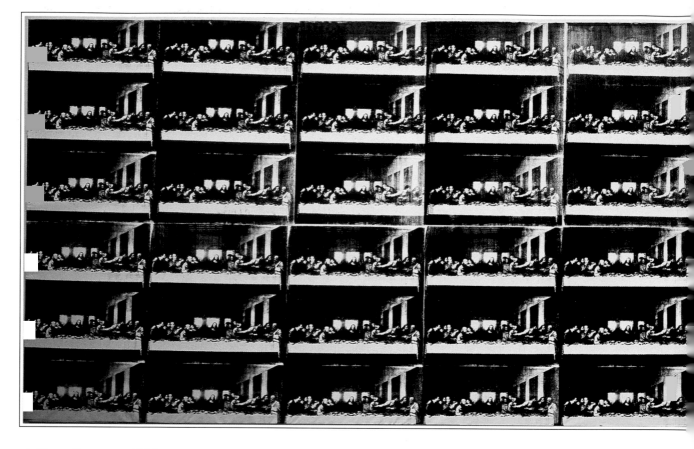

△ **Last Supper** 1986

LEONARDO DA VINCI'S *LAST SUPPER*, the large wall painting in the Refectory of the Church of Santa Maria delle Gracie in Milan, is probably the most revered icon of the Italian Renaissance and is certainly one of the greatest tourist attractions. The painting itself is in an almost totally restored condition (deterioration was due to Leonardo's experimental technique) but the trade in reproductions has produced many imaginative versions, from lurid hand-coloured black and white prints to sculptured versions in different materials and colours. Warhol chose an engraving from an old book for his multi-image versions of the subject. In reproducing the subject 60 times he emphasised that a reproduction of a copy in a different medium will do just as well for the artistically insensitive masses, who buy usually for sentimental religious reasons.

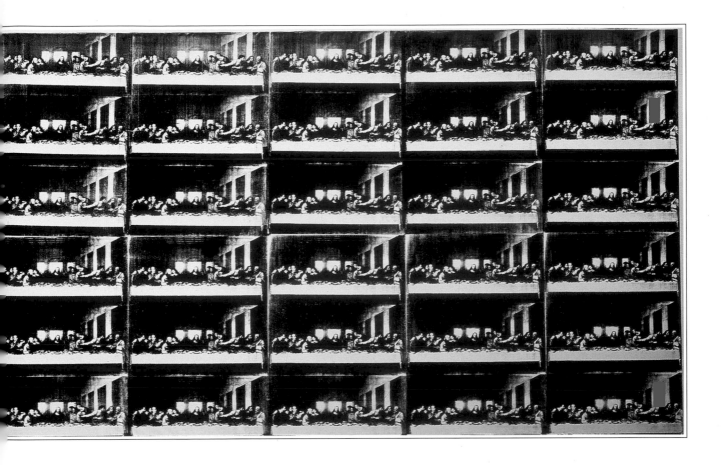

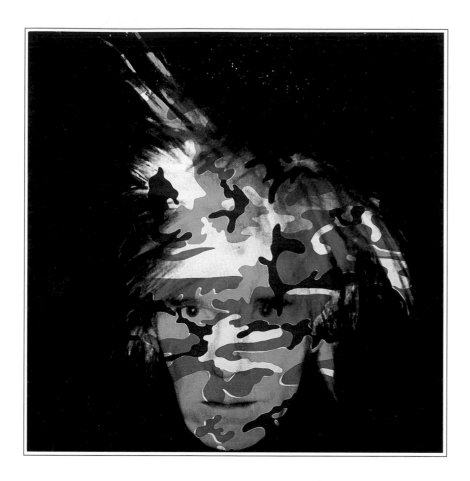

△ **Camouflage Self-portrait** 1986

PAINTED IN THE LAST YEAR of his life – he died in February 1987 – the series of camouflage self-portraits are poignantly effective illustrations of his own self-image. In the 1960s he began to disguise his real personality with a public image of naïvety, and self deprecation. This of course was very far from the truth, as is demonstrated by his early success as a commercial artist. To say that his later life was one of camouflage is to emphasise his need to be ambivalent and equivocal in his work. This portrait epitomises this and also indicates his sharpness in realizing the potential in seemingly unlikely sources. The contrast between the ghostly head and the jigsaw-like army camouflage which disguises the form is a typically inventive Warhol solution.

ACKNOWLEDGEMENTS

The publisher would like to thank the following for their kind permission to reproduce the paintings in this book:

**American Republic Insurance Co., Des Moines, Iowa**: 50-51

**Bridgeman Art Library, London/Christie's, London**: 12; /**Henry N. Abrams Family Collection**: 13; /**Wolverhampton Art Gallery, Staffs.**: 14; /**Saatchi Collection, London**: 15; /**Magyar Nemzeti Galeria, Budapest**: 24; /**Saatchi Collection, London**: 25; /**Tate Gallery, London**: 26; /**Phillips, The International Fine Art Auctioneers**: 27 (right); /**Museum of Modern Art, New York**: 27 (left); /**Private Collection**: 28-29; /**Musee National d'Art Moderne, Paris**: 38; /**Saatchi Collection, London**: 46-47, 56-57, 58, 59; /**Phillips, The International Fine Art Auctioneers**: 61; /**Private Collection**: 64-65; /**Phillips, The International Fine Art Auctioneers**: 66-67, Cover, Half-title; /**Private Collection**: 74-75

**Museum Ludwig, Cologne/Rheinisches Bildarchiv**: 34-35

**Metropolitan Museum of Art, New York, Purchase, Vera G. List Gift, 1987 (1987.88)**: 78

**Museum of Modern Art, New York. Purchase. Photo: c.1995**: 18;

**Saatchi Collection, London**: 39, 42-43

© **1995 The Andy Warhol Foundation, Inc.**: 8-9, 10-11, 20-21, 22-23, 32-33, 36-37, 44, 48-49, 52-53, 54-55, 60, 62-63, 68, 69, 70, 71, 72-73, 76-77; /**Collection Jed Johnson**: 19; /**Collection Thomas Ammann, Zurich**: 30-31; /**Menil Collection, Houston**: 40; /**Collection: Solomon R. Guggenheim Museum, New York**: 41; /**Collection: Rose Art Museum, Brandeis University, Waltham, Massachusetts, Gerritz-Mnuchin Purchase Fund by exchange**: 45

**Kunsthaus Zurich**: 16-17

Every effort has been made to trace the copyright holders and we apologise in advance for any unintentional omissions. We would be pleased to insert the appropriate acknowledgement in any subsequent edition of this publication.